Harry Potter™

SORTING HAT

A BEHIND-THE-SCENES GUIDE
TO THE ENCHANTED HAT

BY JODY REVENSON

a division of

INSIGHT ⊙ EDITIONS

San Rafael, California

INTRODUCTION

At the beginning of each school year at Hogwarts School of Witchcraft and Wizardry, first-year students are placed into one of four houses through the Sorting Ceremony. Once the ancient Sorting Hat is positioned on their heads, it announces whether they will join Gryffindor, Hufflepuff, Ravenclaw, or Slytherin. Some students are easily placed, such as Ron Weasley:

"Ha! Another Weasley. I know just what to do with you . . . Gryffindor!"
and Draco Malfoy: *"Slytherin!"*

But the Sorting Hat finds it difficult to decide which house is the best fit for Harry Potter. It is Harry's desire *not* to be put in Slytherin that helps the hat make its ultimate decision.

"Well, if you're sure . . . better be Gryffindor!"

THE SORTING HAT

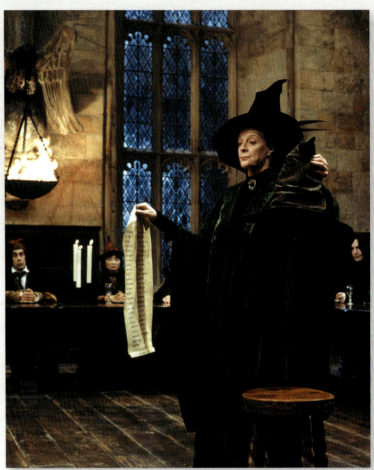

"When I call your name, you will come forth. I shall place the Sorting Hat on your head, and you will be sorted into your houses."

–Professor McGonagall,
Harry Potter and the Sorcerer's Stone

The filmmakers originally thought that the Sorting Hat would be enacted by a puppet. A hat puppet was created and tested, but, as costume designer Judianna Makovsky recalls, "It didn't look like a hat. It looked like a puppet." So *Harry Potter and the Sorcerer's Stone* director Chris Columbus asked Judianna if she could make the Sorting Hat. "I can make a hat," she replied, "but I can't make it talk!" Judianna fabricated a wide-brimmed pointed hat and brought it to the set for approval. "Everyone said it was a beautiful hat," Judianna continues. "And then Robert Legato, the visual effects supervisor, asked, 'Where does it talk?' And Chris said, 'She made the hat. *You* make it talk!'"

An Animated Hat

The Sorting Hat that we see placed on the students' heads in the films was partially a real hat and partially a form of motion-capture technology. The flaps that hung down from it were real, and the brim, Judianna Makovsky describes, was "basically a ring around their heads." This was topped by a framework and pieces to be used as registration points to line up the real and animated versions. The Sorting Hat that Harry talks to in Dumbledore's office in *Harry Potter and the Chamber of Secrets* was a completely digital construction.

A Real Hat

Seven Sorting Hats were made for practical uses, based on the "master hat" seen in the first film. As costume fabricator Steve Kill explains, first a leather material was fashioned into a cone form and soaked in hot water for ten minutes. Then Steve "squashed it down within itself" and left it overnight atop a heating unit. After the hat was dry and solid, wire was inserted to keep its shape. Some hats had a horsehair canvas lining for more stability. The hats were then dyed, aged, and imprinted with Celtic symbols. "The wrinkles were different on each one," Steve admits, "but you never see two of them next to each other!"

Professor McGonagall

Transfiguration teacher and Deputy Headmistress of Hogwarts Minerva McGonagall leads the first years into the Great Hall and supervises the Sorting Ceremony in *Harry Potter and the Sorcerer's Stone*. She places the hat on each student's head in a no-nonsense manner. "I suppose I'm the one who keeps them in order," actress Dame Maggie Smith says. "I care very much about them, obviously, but I'm really fairly fierce." Per the book, McGonagall was dressed in emerald green robes, which each costume designer embraced as the dominant color for her attire. It was Dame Maggie who asked that since her character's name was Scottish her wardrobe should reflect that, with traces of tartans, plaids, and Celtic imagery.

Professor McGonagall wore a series of hats that displayed her Scottish heritage. Her tall black witch's hat shows a hint of a traditional Scottish tam with a green-and-black checkered band that peaks out from under the brim. A modest cockade of game-bird feathers completes the look. And it was actress Dame Maggie Smith who suggested a wizarding but still Scottish take on a traditional deerstalker cap (think Sherlock Holmes) that she wears outside at Quidditch matches. Even her dressing gown and peaked nightcap are rendered in a tartan plaid.

THE GREAT HALL

"Welcome to Hogwarts. Now, in a few moments, you will
pass through these doors and join your classmates."

–Professor McGonagall, *Harry Potter and the Sorcerer's Stone*

First-year Hogwarts students enter the Great Hall
to be sorted into their houses. Production designer
Stuart Craig based the room on the sixteenth-century
Christ Church College at Oxford University, with a
few alterations. The windows in Christ Church are set
high up, and Stuart wanted them seen onscreen. "So
we made them longer," he explains, "and brought the
sills down so you could see out." Outside the windows,
the set was circled by a hand-painted cyclorama that
showed the view from the castle. "This was no static
painting," Stuart declares. "When it was supposed to be
winter in the films, a different painting was used with
snow painted on the mountaintops."

Hot and Cold

Chris Columbus, director of the first two Harry Potter films, remembers being on the Warner Bros. Studio Leavesden set of the Great Hall when filming began on *Harry Potter and the Sorcerer's Stone.* "It was freezing cold! And the roof leaked." Hogwarts and the Great Hall needed to be "this warm, loving place," Chris continues, "so we built a lot of fire into it." One side of the room has a huge hearth topped by the Hogwarts crest, and flambeaux bowls were placed between the windows, held by sculptures representing the four house creatures. Daniel Radcliffe admits he occasionally got so warm in his robes that he would sometimes become sleepy!

The Great Hall Ceiling

"It's not real, the ceiling. It's just bewitched to look like the night sky.
I read about it in *Hogwarts: A History*."

–Hermione Granger, *Harry Potter and the Sorcerer's Stone*

So how do you create a bewitched ceiling? Stuart Craig explored different ideas to achieve the ever-changing view. One idea was perhaps the ceiling was "made" of glass; another thought was that it was "made" of sky. Stuart and concept artist Dermot Power then came up with the concept that maybe an architect of Hogwarts had cast a globe-like enchantment to bisect the roof and show the sky above it. Moonlit nights, falling snow, and even the entire cosmos of stars and planets would be seen through the transparent beams of the ceiling. The digital artists defined the horizon line "inside" the Great Hall, and so when rain or snow fell, it always disappeared at the same level.

The Great Hall Floor

When production designer Stuart Craig decided what material to use for the floor of the Great Hall, he set that decision in stone. Literally. Stuart chose to use slabs of Yorkstone, which cost a bit more than a typical painted fiberglass or plaster floor. This proved to be a very smart decision since the floor was trod upon by hundreds of actors and laid with camera tracks and lighting equipment for ten years of filming. Yorkstone has been used throughout England for thousands of years, so it was entirely appropriate for the floor of the thousand-year-old Hogwarts School of Witchcraft and Wizardry.

The Great Hall
Seating Arrangements

Once the Great Hall was built, seating was needed for the four hundred or so students. Normally, tables and chairs would be bought or rented to furnish a set. But, as Stephenie McMillan, set decorator for all eight Harry Potter films, maintains, "Making [the furniture] was the obvious choice in this case because there's nowhere I know where you could buy or rent four hundred feet of refectory tables or the eight hundred feet of benches that went with them." In order to make these look aged, they were distressed using chains and sharp tools. Production designer Stuart Craig also encouraged the actors to carve images or their names into them, as students have been known to do!

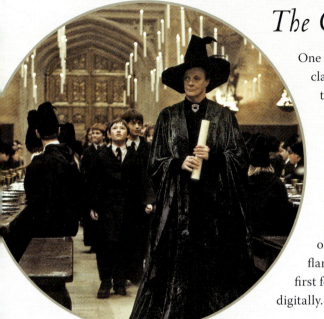

The Great Hall Candles

One of most amazing sights Harry Potter and his classmates see when they enter the Great Hall for the Sorting Ceremony in *Harry Potter and the Sorcerer's Stone* are the floating candles that illuminate the room. Even more amazing is the fact that in this first scene the candles were real! The 370 candles were initially plastic tubes filled with oil and a burning wick. Each candle was held by two thin wires suspended from rigs that moved up and down to give them the illusion of floating. But drafts in the Great Hall blew the flames onto the wires, burning them up. After the first few candles fell, it was decided to light the Hall digitally.

Flare Flair

Going digital let the filmmakers go candle-crazy. Five models of candles were designed, with different sizes, widths, and rotations. Six different flame cycles were randomly assigned and their burn rates varied so that no two candles were alike. New arrangements for the candles were created that included circles, spirals, arches, tiered cakes, and even starfish shapes.

DUMBLEDORE'S OFFICE

"Sherbet Lemon."

–Professor McGonagall, *Harry Potter and the Chamber of Secrets*

When production designer Stuart Craig and his team were assigning classrooms and offices for the Hogwarts teachers, they had to think where they would place Albus Dumbledore's office. Stuart saw three little cantilevered turrets on one of the tallest towers and thought, "Well, that's the place I'd like to be," and so it became the headmaster's office. "We gave it not just three different spaces," says Stuart, "but we gave it different landings, and different heights as well. It was very complex, and at the same time peaceful, stuck three hundred feet in the air on a two-hundred-foot-high cliff way above a Scottish loch, like an aerie."

Dumbledore Décor

Set decorator Stephenie McMillan filled the three levels of Dumbledore's office with astrolabes, celestial spheres, a telescope, and globes etched with astrological figures. The hundreds of books that line the walls were actually covered phone directories. Other iconic elements include the Sorting Hat, which sits on a shelf; portraits of previous headmasters sleeping; and the Pensieve, within which memories can be viewed. The cabinets against the walls were filled with thousands of memory vials hand-labeled by the graphics department. Because the office was small, it was constructed with glass-fronted bookcases and what moviemakers call "wild walls"—walls that are removable. This made it easier for cameras to shoot from different angles.

FAWKES

Fawkes is a phoenix, a mystical bird with an endless number of life cycles. Harry Potter meets him in Albus Dumbledore's office in *Harry Potter and the Chamber of Secrets* just as Fawkes bursts into flames at the end of one life cycle. Happily, phoenixes are reborn from the ashes. Dumbledore additionally informs Harry that phoenixes can carry immensely heavy loads and have tears that can heal wounds. Both these abilities will help Harry during his battle with the poisonous Basilisk in the Chamber of Secrets.

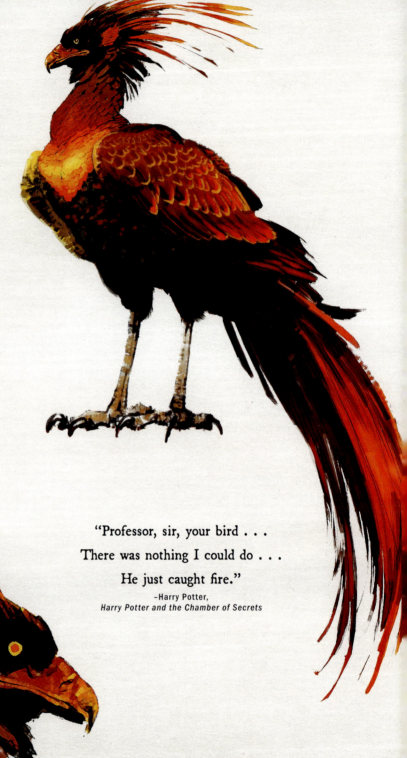

"Professor, sir, your bird . . .
There was nothing I could do . . .
He just caught fire."
—Harry Potter,
Harry Potter and the Chamber of Secrets

Bird on Fire

The adult Fawkes was based on the sea eagle, with an exaggerated crest like a bird of paradise. His coloring is a combination of fiery dark reds and burnt oranges, with golds and lighter oranges on his throat and breast. Fawkes's feathers were acquired from game birds, including pheasants. Other feathers were specially dyed by key animatronic model designer Val Jones, then inserted into the model one by one.

Almost a Real Bird

Fawkes was produced in both animatronic and digital constructions. The animatronic Fawkes in Dumbledore's office could stretch his wings, raise his crest, blink, and move back and forth on his perch. It took ten controllers to generate all his movements. This Fawkes was also able to lean over and cry tears onto Harry's arm when Harry is injured by the Basilisk. Fawkes seemed so lifelike that actor Richard Harris (Albus Dumbledore) thought he was a real-live trained bird. He wouldn't believe otherwise until special makeup effects artist Nick Dudman pressed a control button and made Fawkes move. Nick thought this was the greatest compliment he and his creature shop team could have ever gotten.

Flying Lessons

Most of the creatures in the Harry Potter films were created as full-scale, fully painted models that were cyberscanned into the computer for animation. Though Fawkes was created as an animatronic version, he was one of the few not scanned for digital use. The digital team referenced the visual development artwork and filmed the movement and flight of real birds, including the blue macaw and the turkey vulture, in order to create the Fawkes that flew.

SWORD OF GRYFFINDOR

"It would take a true Gryffindor to pull that out of the Hat."

–Albus Dumbledore,
Harry Potter and the Chamber of Secrets

Harry Potter defeats the Basilisk in *Harry Potter and the Chamber of Secrets* with the Sword of Gryffindor. As he's trying to battle the giant serpent, Fawkes flies in and drops the Sorting Hat near him. Magically materializing within the Hat is the Sword, which Harry uses to stab the Basilisk. Goblin-made, the Sword is able to absorb qualities that strengthen it, and so, after soaking up the Basilisk's venom, it is able to destroy three Horcruxes: Dumbledore uses it to destroy Marvolo Gaunt's ring; Ron Weasley, the Slytherin locket; and Neville Longbottom beheads the snake Nagini, the final Horcrux and Voldemort's companion.

A Sharp Design

"Only a goblin would recognize that this
is the true Sword of Gryffindor."

–Griphook, *Harry Potter and the Deathly Hallows – Part 2*

The design of the Sword of Gryffindor was inspired by research
into medieval swords and by a real sword the props team
purchased at an auction. The image of a man inscribed on
the grip is presumed to be its namesake, Godric Gryffindor.
Ruby-colored jewels, the color of Gryffindor house, are set into
its pommel and guard. A collapsible version was created for
Neville Longbottom to pull out of the Sorting Hat in *Harry
Potter and the Deathly Hallows – Part 2*.

HOGWARTS HEADGEAR

The students and teachers at Hogwarts and other wizarding schools wore their own unique head coverings throughout the course of the Harry Potter films. Here are a few.

Brimming Over

The students in *Harry Potter and the Sorcerer's Stone* wore brimless pointed hats designed by Judianna Makovsky that could be folded and stuffed into a pocket in their robes. For *Harry Potter and the Prisoner of Azkaban*, new costume designer Jany Temime wanted to make "wizardy wear" more contemporary. As she explains, "Though your great-great-grandmother wore a pointed hat, and you would, too, it would eventually be modernized. So I put a pointed hood on the back of the robes, which was a link between tradition and the urban hoodie of the twenty-first century."

Luna Lovegood's Lion Hat

Though Luna Lovegood was a Ravenclaw, she showed her support for the Gryffindor Quidditch team in *Harry Potter and the Half-Blood Prince* by wearing a hat shaped like a lion. Actress Evanna Lynch sketched out her version for the designers to follow. "I wanted it to look like it was eating my head," Evanna explains. "It was actually very light and comfortable, and I often forgot I was wearing it."

Beauxbatons Chapeaux

The students of Beauxbatons Academy of Magic, participants in the Triwizard Tournament in *Harry Potter and the Goblet of Fire*, come from a milder climat than Hogwarts and wear clothes too thin for the weather. Fortunately, they we a wizard version of a trilby hat in a soft felt fabric to provide some warmth.

Durmstrang Shapkas

Durmstrang Institute students who also compete for the Triwizard Cup wear high-collared fur-lined coats to cope with their cold northern European location. They sport traditional Russian shapka hats that have peaked tops, and ushanka caps, which have a round crown and ear flaps that can be tied up out of the way when the weather is more temperate.

Albus Dumbledore

The Hogwarts headmaster, Albus Dumbledore, was played by actor Richard Harris in *Harry Potter and the Sorcerer's Stone* and *Harry Potter and the Chamber of Secrets* before his death in 2002. His lush wardrobe was created in rich velvety fabrics that evoked medieval tapestries. His hats also had a Late Middle-Ages feel, with raised, textured brims and soft points.

Michael Gambon took over the role in *Harry Potter and the Prisoner of Azkaban.* His clothing had more of a "hippie-ish" feel and so he wore robes of tie-dyed silks. Jany Temime topped these outfits with embroidered and tasseled Victorian-style smoking caps. Dumbledore rarely wore a hat in *Harry Potter and the Half-Blood Prince* to indicate a growing frailty.

Madame Hooch

The Hogwarts flying instructor in *Harry Potter and the Sorcerer's Stone*, Madame Hooch, wore a black, pleated hat that ended in a purple-and-white spray resembling a broomstick.

Professor Sprout

Herbology professor Pomona Sprout was appropriately dressed in earth tones of brown and green in *Harry Potter and the Chamber of Secrets*. Her burlap witch's hat "sprouts" leaves from its point.

MAKE IT YOUR OWN

Paint this model after it's been fully assembled.

One of the great things about IncrediBuilds™ models is that each one is completely customizable. The untreated natural wood can be decorated with paints, pencils, pens, beads, sequins—the list goes on and on!

Before you start building and decorating your model, read through the included instruction sheet so you understand how all the pieces come together. Then choose a theme and make a plan. Do you want to make an exact replica of the Sorting Hat or something completely different? The choice is yours! Here is an example to get those creative juices flowing.

When making a replica, it's always good to study an actual image of what you are trying to copy. Look closely at the details throughout this book and brainstorm how you can re-create them.

WHAT YOU NEED

- Paint (black, dark brown, brown, and tan)

- Paintbrush

WHAT YOU MIGHT WANT

- Light brown chalk pastel

- Cotton swab

- Water for blending

STEPS

1. Start by painting the entire model brown.
2. Using dark brown paint, follow the laser engravings to help paint in the folds and details on the hat.
3. Then, to give the folds more of a 3D effect, outline some of the engravings with a lighter tan paint. You can also blend the tan paint into the hat with water for a more seamless look.
4. Paint the eyes and the mouth of the sorting hat black.
5. Optionally, you can add a finishing touch to your model by using light brown chalk pastel to lighten the sorting hat's face. Use a cotton swab to blend the chalk in for the nose and eyebrows of the face.

TIP:
If you want the hat to look more like leather, use matte-finish paints.

IncrediBuilds™
A Division of Insight Editions, LP
PO Box 3088
San Rafael, CA 94912
www.incredibuilds.com
www.insighteditions.com

 Find us on Facebook: www.facebook.com/InsightEditions
 Follow us on Twitter: @insighteditions

Publisher: Raoul Goff
Associate Publisher: Jon Goodspeed
Art Director: Chrissy Kwasnik
Designer: Alison Corn
Editor: Gregory Solano
Managing Editor: Alan Kaplan
Editorial Assistant: Hilary VandenBroek
Production Editors: Lauren LePera and Carly Chillmon
Associate Production Manager: Sam Taylor
Model Designer: Liang Tujian, TeamGreen
Craft Sample: Jill Turney

Library of Congress Cataloging-in-Publication Data available.

ISBN: 978-1-68298-115-3

Insight Editions, in association with Roots of Peace, will plant two trees for each tree used in the manufacturing of this book. Roots of Peace is an internationally renowned humanitarian organization dedicated to eradicating land mines worldwide and converting war-torn lands into productive farms and wildlife habitats. Roots of Peace will plant two million fruit and nut trees in Afghanistan and provide farmers there with the skills and support necessary for sustainable land use.

Manufactured in China

10 9 8 7 6 5 4 3 2 1